DECORATIVE AND DISPLAY

NUMBERS

739 COMPLETE FONTS

SELECTED AND ARRANGED BY

JULIE SOLO

FROM THE
SOLOTYPE TYPOGRAPHERS ARCHIVE

DOVER PUBLICATIONS, INC. · NEW YORK

Published in Canada by General Publishing Company, Ltd., 30 Lesmill Road, Don Mills, Toronto, Ontario.
Published in the United Kingdom by Constable and Company, Ltd., 10 Orange Street, London WC2H 7EG.

Decorative and Display Numbers: 739 Complete Fonts is a new work, first published by Dover Publications, Inc., in 1985.

DOVER *Pictorial Archive* SERIES

Manufactured in the United States of America
Dover Publications, Inc., 31 East 2nd Street, Mineola, N.Y. 11501

Library of Congress Cataloging-in-Publication Data

Solo, Julie.
 Decorative and display numbers.

 (Dover pictorial archive series)
 1. Numerals—Printing—Specimens. 2. Numerals, writing of.
3. Type and type-founding—Display type. 4. Type Ornaments.
I. Title. II. Series.
Z250.25.S66 1985 686.2'24 84-21097
ISBN 0-486-24787-2 (pbk.)

NN 50 .25
. D 4 3
i 9 8 5

1234567890 A

1234567890 B

1234567890 C

1234567890 D

1234567890 E

1234567890 F

1234567890 G

A 1234567890

B 1234567890

C 1234567890

D 1234567890

E 1234567890

F 1234567890

G 1234567890

2

1234567890 A

1234567890 B

1234567890 C

1234567890 D

1234567890 E

1234567890 F

1234567890 G

3

A 1234567890

B 1234567890

C 1234567890

D 1234567890

E 1234567890

F 1234567890

G 1234567890

H 1234567890

4

1234567890 A

1234567890 B

1234567890 C

1234567890 D

1234567890 E

1234567890 F

1234567890 G

5

A 1234567890

B 1234567890

C 1234567890

D 1234567890

E 1234567890

F 1234567890

G 1234567890

6

1234567890 A

1234567890 B

1234567890 C

1234567890 D

1234567890 E

1234567890 F

1234567890 G

7

A 1234567890

B 1 2 3 4 5 6 7 8 9 0

C 1234567890

D 1234567890

E 1234567890

F 1234567890

G 1234567890

1234567890 A

1234567890 B

1234567890 C

1234567890 D

1234567890 E

1234567890 F

1234567890 G

1234567890 H

A 1234567890

B 1234567890

C 1234567890

D 1234567890

E 1234567890

F 1234567890

G 1234567890

H 1234567890

1234567890 A

1234567890 B

1234567890 C

1234567890 D

1234567890 E

1234567890 F

1234567890 G

11

A 1234567890

B 1234567890

C 1234567890

D 1234567890

E 1234567890

F 1234567890

G 1234567890

H 1234567890

1234567890 A

1234567890 B

1234567890 C

1234567890 D

1234567890 E

1234567890 F

1234567890 G

1234567890 H

A 1234567890

B 1234567890

C 1234567890

D 1234567890

E 1234567890

F 1234567890

G 1234567890

H 1234567890

14

1234567890 A

1234567890 B

1234567890 C

1234567890 D

1234567890 E

1234567890 F

1234567890 G

1234567890 H

15

A 1234567890

B 1234567890

C 1234567890

D 1234567890

E 1234567890

F 1234567890

G 1234567890

16

1234567890 A

1234567890 B

1234567890 C

1234567890 D

1234567890 E

1234567890 F

1234567890 G

1234567890 H

A 1234567890

B 1234567890

C 1234567890

D 1234567890

E 1234567890

F 1234567890

G 1234567890

H 1234567890

1234567890 A

1234567890 B

1234567890 C

1234567890 D

1234567890 E

1234567890 F

1234567890 G

19

A 1234567890

B 1234567890

C 1234567890

D 1234567890

E 1234567890

F 1234567890

G 1234567890

H 1234567890

1234567890 A

1234567890 B

1234567890 C

1234567890 D

1234567890 E

1234567890 F

1234567890 G

1234567890 H

A 1234567890

B 1234567890

C 1234567890

D 1234567890

E 1234567890

F 1234567890

G 1234567890

H 1234567890

22

1234567890 A

1234567890 B

1234567890 C

1234567890 D

1234567890 E

1234567890 F

1234567890 G

A 1234567890

B 1234567890

C 1234567890

D 1234567890

E 1234567890

F 1234567890

G 1234567890

1234567890 A

1234567890 B

1234567890 C

1234567890 D

1234567890 E

1234567890 F

1234567890 G

A 1234567890

B 1234567890

C 1234567890

D 1234567890

E 1234567890

F 1234567890

G 1234567890

H 1234567890

1234567890 A

1234567890 B

1234567890 C

1234567890 D

1234567890 E

1234567890 F

1234567890 G

A 1234567890

B 1234567890

C 1234567890

D 1234567890

E 1234567890

F 1234567890

G 1234567890

1234567890 A

1234567890 B

1234567890 C

1234567890 D

1234567890 E

1234567890 F

1234567890 G

29

A 1234567890

B 1234567890

C 1234567890

D 1234567890

E 1234567890

F 1234567890

G 1234567890

1234567890 A

1234567890 B

1234567890 C

1234567890 D

1234567890 E

1234567890 F

1234567890 G

1234567890 H

31

A 1234567890

B 1234567890

C 1234567890

D 1234567890

E 1234567890

F 1234567890

G 1234567890

H 1234567890

32

1234567890 A

1234567890 B

1234567890 C

1234567890 D

1234567890 E

1234567890 F

1234567890 G

A 1234567890

B 1234567890

C 1234567890

D 1234567890

E 1234567890

F 1234567890

G 1234567890

1234567890 A

1234567890 B

1234567890 C

1234567890 D

1234567890 E

1234567890 F

1234567890 G

35

A *1234567890*

B 1234567890

C **1234567890**

D **1234567890**

E 1234567890

F **1234567890**

G **1234567890**

H **1234567890**

36

1234567890 A

1234567890 B

1234567890 C

1234567890 D

1234567890 E

1234567890 F

1234567890 G

1234567890 H

A 1234567890

B 1234567890

C 1234567890

D 1234567890

E 1234567890

F 1234567890

G 1234567890

H 1234567890

38

1234567890 A

1234567890 B

1234567890 C

1234567890 D

1234567890 E

1234567890 F

1234567890 G

1234567890 H

A 1234567890

B 1234567890

C 1234567890

D 1234567890

E 1234567890

F 1234567890

G 1234567890

1234567890 A

1234567890 B

1234567890 C

1234567890 D

1234567890 E

1234567890 F

1234567890 G

1234567890 H

A 1234567890

B 1234567890

C 1234567890

D 1234567890

E 1234567890

F 1234567890

G 1234567890

H 1234567890

42

1234567890 A

1234567890 B

1234567890 C

1234567890 D

1234567890 E

1234567890 F

1234567890 G

43

A 1234567890

B 1234567890

C 1234567890

D 1234567890

E 1234567890

F 1234567890

G 1234567890

H 1234567890

1234567890 A

1234567890 B

1234567890 C

1234567890 D

1234567890 E

1234567890 F

1234567890 G

45

A 1234567890

B 1234567890

C 1234567890

D 1234567890

E 1234567890

F 1234567890

G 1234567890

1234567890 A

1234567890 B

1234567890 C

1234567890 D

1234567890 E

1234567890 F

1234567890 G

47

A 1234567890

B 1234567890

C 1234567890

D 1234567890

E 1234567890

F 1234567890

G 1234567890

H 1234567890

48

1234567890 A

1234567890 B

1234567890 C

1234567890 D

1234567890 E

1234567890 F

1234567890 G

1234567890 H

49

A 1234567890

B **1234567890**

C 1234567890

D **1234567890**

E 1234567890

F 1234567890

G 1234567890

50

1234567890 A

1234567890 B

1234567890 C

1234567890 D

1234567890 E

1234567890 F

1234567890 G

A 1234567890

B 1234567890

C 1234567890

D 1234567890

E 1234567890

F 1234567890

1234567890 A

1234567890 B

1234567890 C

1234567890 D

1234567890 E

1234567890 F

1234567890 G

53

A 1234567890

B 1234567890

C 1234567890

D 1234567890

E 1234567890

F 1234567890

G 1234567890

1234567890 A

1234567890 B

1234567890 C

1234567890 D

1234567890 E

1234567890 F

1234567890 G

1234567890 H

55

A 1234567890

B 1234567890

C 1234567890

D 1234567890

E 1234567890

F 1234567890

G 1234567890

56

1234567890 A

1234567890 B

1234567890 C

1234567890 D

1234567890 E

1234567890 F

1234567890 G

57

A 1234567890

B 1234567890

C 1234567890

D 1234567890

E 1234567890

F 1234567890

G 1234567890

H 1234567890

1234567890 A

1234567890 B

1234567890 C

1234567890 D

1234567890 E

1234567890 F

1234567890 G

A 1234567890

B **1234567890**

C *1234567890*

D 1234567890

E 1234567890

F 1234567890

G 1234567890

1234567890 A

1234567890 B

1234567890 C

1234567890 D

1234567890 E

1234567890 F

1234567890 G

A 1234567890

B 1234567890

C 1234567890

D 1234567890

E 1234567890

F 1234567890

G 1234567890

1234567890 A

1234567890 B

1234567890 C

1234567890 D

1234567890 E

1234567890 F

1234567890 G

63

A 1234567890

B 1234567890

C 1 2 3 4 5 6 7 8 9 0

D 1234567890

E 1234567890

F 1234567890

G 1234567890

1234567890 A

1234567890 B

1234567890 C

1234567890 D

1234567890 E

1234567890 F

1234567890 G

1234567890 H

65

A 1234567890

B 1234567890

C 1234567890

D 1234567890

E 1234567890

F 1234567890

66

1234567890 A

1234567890 B

1234567890 C

1234567890 D

1234567890 E

1234567890 F

A 1234567890

B 1234567890

C 1234567890

D 1234567890

E 1234567890

F 1234567890

G 1234567890

68

1234567890 A

1234567890 B

1234567890 C

1234567890 D

1234567890 E

1234567890 F

1234567890 G

69

A 1234567890

B 1234567890

C 1234567890

D 1234567890

E 1234567890

F 1234567890

G 1234567890

1234567890 A

1234567890 B

1234567890 C

1234567890 D

1234567890 E

1234567890 F

1234567890 G

A 1234567890

B 1234567890

C 1234567890

D 1234567890

E 1234567890

F 1234567890

G 1234567890

1234567890 A

1234567890 B

1234567890 C

1234567890 D

1234567890 E

1234567890 F

1234567890 G

73

A 1234567890

B 1234567890

C 1234567890

D 1234567890

E 1234567890

F 1234567890

G 1234567890

1234567890 A

1234567890 B

1234567890 C

1234567890 D

1234567890 E

1234567890 F

1234567890 G

75

A 1234567890

B 1234567890

C 1234567890

D 1234567890

E 1234567890

F 1234567890

G 1234567890

H 1234567890

1234567890 A

1234567890 B

1234567890 C

1234567890 D

1234567890 E

1234567890 F

1234567890 G

1234567890 H

A 1234567890

B 1234567890

C 1234567890

D 1234567890

E 1234567890

F 1234567890

G 1234567890

H 1234567890

1234567890 A

1234567890 B

1234567890 C

1234567890 D

1234567890 E

1234567890 F

1234567890 G

79

A 1234567890

B 1234567890

C 1234567890

D 1234567890

E 1234567890

F 1234567890

G 1234567890

1234567890 A

1234567890 B

1234567890 C

1234567890 D

1234567890 E

1234567890 F

1234567890 G

A 1234567890

B 1234567890

C 1234567890

D 1234567890

E 1234567890

F 1234567890

G 1234567890

1234567890 A

1234567890 B

1234567890 C

1234567890 D

1234567890 E

1234567890 F

1234567890 G

83

A 1234567890

B 1234567890

C 1234567890

D 1234567890

E 1234567890

F 1234567890

G 1234567890

1234567890 A

1234567890 B

1234567890 C

1234567890 D

1234567890 E

1234567890 F

1234567890 G

1234567890 H

A 1234567890

B 1234567890

C 1234567890

D 1234567890

E 1234567890

F 1234567890

G 1234567890

1234567890 A

1234567890 B

1234567890 C

1234567890 D

1234567890 E

1234567890 F

1234567890 G

1234567890 H

A 1234567890

B 1234567890

C 1234567890

D 1234567890

E 1234567890

F 1234567890

G 1234567890

88

1234567890 A

1234567890 B

1234567890 C

1234567890 D

1234567890 E

1234567890 F

1234567890 G

89

A 1234567890

B 1234567890

C 1234567890

D 1234567890

E 1234567890

F 1234567890

G 1234567890

H 1234567890

90

1234567890 A

1234567890 B

1234567890 C

1234567890 D

1234567890 E

1234567890 F

1234567890 G

A 1234567890

B 1234567890

C 1234567890

D 1234567890

E 1234567890

F 1234567890

G 1234567890

H 1234567890

92

1234567890 A

1234567890 B

1234567890 C

1234567890 D

1234567890 E

1234567890 F

1234567890 G

1234567890 H

93

A 1234567890

B 1234567890

C ↑1234567890

D 1234567890

E 1234567890

F 1234567890

G 1234567890

H 1234567890

1234567890 A

1234567890 B

1234567890 C

1234567890 D

1234567890 E

1234567890 F

1234567890 G

1234567890 H

95

A 1234567890

B 1234567890

C 1234567890

D 1234567890

E 1234567890

F 1234567890

G 1234567890

H 1234567890

96

1234567890 A

1234567890 B

1234567890 C

1234567890 D

1234567890 E

1234567890 F

11 22 33 44 55 66 77 88 99 00 G

1234567890 H

97

A 1234567890

B 1234567890

C 1234567890

D 1234567890

E 1234567890

F 1234567890

G 1234567890

H 1234567890

98

1234567890 A

1234567890 B

1234567890 C

1234567890 D

1234567890 E

1234567890 F

1234567890 G

1234567890 H

99

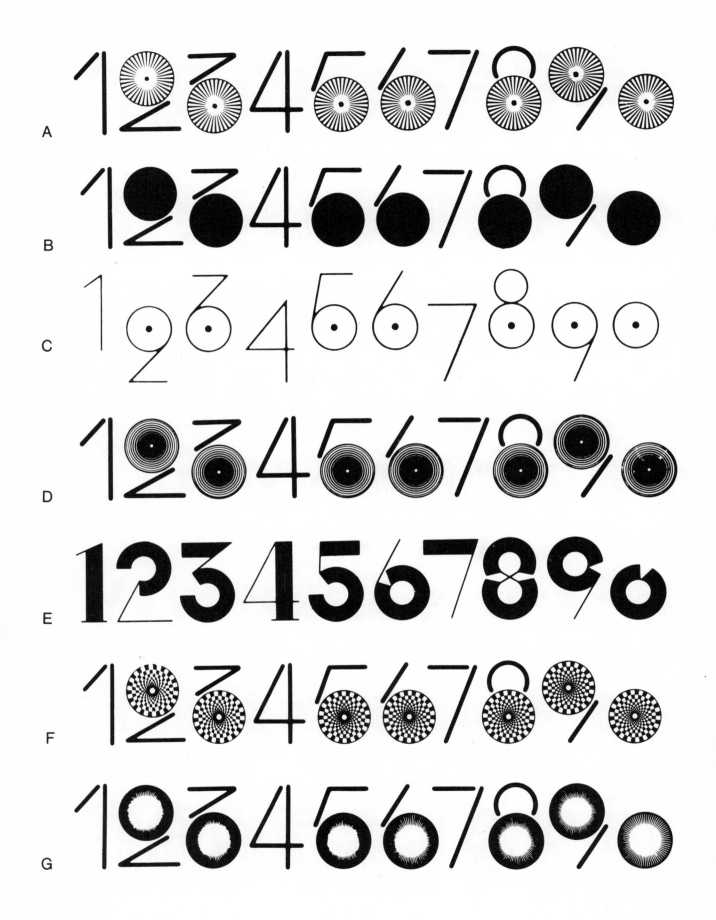

A

B

C

D

E

F

G